THE BLITZ

Published by IWM, Lambeth Road, London SE1 6HZ
iwm.org.uk

ISBN 978-1-912423-54-5

A catalogue record for this book is available from the British Library.
Printed and bound by Gomer Press Limited.
Colour reproduction by DL Imaging.

Every effort has been made to contact all copyright holders.
The publishers will be glad to make good in future editions any
error or omissions brought to their attention.

Front cover. Firemen fight fires in the centre of Manchester, December 1940.

Back cover. In a trench shelter waterlogged by rain, people sleep on hard,
narrow benches, 1940.

THE BLITZ

Ian Kikuchi

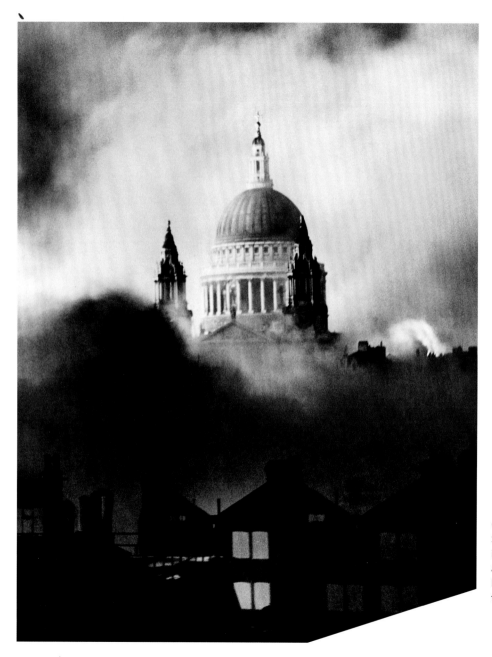

INTRODUCTION

Catching sight of
St Paul's Cathedral dome,
illuminated by flames
and wreathed in smoke,
Herbert Mason captured
this iconic image.

From the autumn of 1940 the people of Britain faced almost unimaginable dangers. For months on end, nightfall brought droning aircraft overhead, showering towns and cities with bombs. Explosions ripped through homes and workplaces, and firebombs sparked devastating blazes. By spring 1941, more than 40,000 people had been killed. For a period defined by sudden thunderous violence from the sky, the name 'Blitz' – from the German word for lightning – could hardly be more apt.

More than 80 years have now passed since the Blitz. Few people in Britain remember the nights the bombs fell. As the Blitz – and indeed the Second World War as a whole – passes out of living memory and into history, it becomes more important to study and share the historic records of that time.

The Imperial War Museum (IWM) was established in 1917 to record the war effort and sacrifice of Britain and its former empire in the First World War. With the outbreak of a second great conflict in 1939, the museum's remit expanded. In time, the museum acquired a vast photographic archive, preserving the work of photographers of all kinds. This book draws upon the museum's unparalleled photograph archive. Whether taken by photojournalists on assignment to newspapers and agencies, or by official photographers commissioned by the wartime Ministry of Information, all captured unique views of the destruction wrought by bombing.

In the decade before the Blitz, aviation technology progressed rapidly. While opening new opportunities for civilian air travel, the ability of advanced aircraft to carry heavy payloads, at high speed over long distances, also made aeroplanes an increasingly potent strategic weapon. For centuries, Britain's sea borders had protected the country against invasion. Shocked by the experience of German bombing by airship and aeroplane during the First World War, the looming threat of catastrophic bombing became a national preoccupation in Britain in the 1930s.

Fearing that a future war might begin with bombing raids so devastating as to cause a widespread breakdown of society, Parliament passed the 1937 Air Raid Precautions Act, requiring councils to prepare to provide essential services in the event of air attacks. Councils distributed millions of gas masks, and erected public bomb shelters. Householders dug up their back gardens to install corrugated steel Anderson shelters. With the outbreak of war, millions of children were evacuated from threatened cities to safer areas, prompting one of the war's most dramatic social changes. As trainloads of children steamed for the countryside, a nightly blackout descended, obliging people to curtain off their windows and plunging streets into darkness. By the onset of the Blitz, thousands of men and women were serving as air raid wardens, firefighters, first aiders, ambulance drivers, as members of rescue and demolition parties, and in countless other roles. When the air raid sirens sounded, and most people retreated to the relative safety of their shelters, this army of civil defenders went into action. They will be a frequent sight in the pages of this book.

The Blitz formed a key phase in Britain's experience of the Second World War. On 7 September 1940, the German Air Force

— the Luftwaffe — made a large daylight attack on London. Over the previous two months, the Luftwaffe had struggled to defeat the Royal Air Force in the Battle of Britain. Now Germany would attempt to force Britain's defeat by the destruction of its industry — by attacking inland industrial cities including Coventry and Birmingham — and by attacking the docks that allowed Britain to import raw materials, food and equipment from overseas. In targeting Britain's port cities — including London, Liverpool, Manchester, Hull, Glasgow, Belfast, Swansea, Bristol, Plymouth and others — German strategists hoped their bombers could impose an aerial blockade, complementing the efforts at sea of the German Navy's submarine captains, preying upon British merchant ships.

By spring 1941 the Luftwaffe had devastated swathes of British cities and towns, and caused immense loss of life. But ultimately their strategy failed; Germany's bombers weren't capable of causing the paralysing damage their plan required. The Nazis' hopes that bombs might shatter Britain's will to continue fighting proved fruitless in the face of a resilient social and political structure.

This resilience, proved under fire, has become one of the enduring national memories of the Blitz. It is entirely proper that we remember and honour those who demonstrated courage, whether in doing their duty as a warden or fireman, or by simply enduring long and fearful nights of bombing. But the essence of war is violence, and we must be careful not to romanticise a period that saw men, women and children torn to pieces by bombs, and left others bewildered and distraught, their homes and livelihoods reduced to rubble and ashes. Images of the dead, the wounded and the homeless should remind us that war is not something to be celebrated.

On 30 September 1938, amid diplomatic crisis, British Prime Minister Neville Chamberlain returns from a meeting with Adolf Hitler. He holds up a signed piece of paper, now in IWM's collection, expressing Britain and Germany's '[desire] never to go to war with one another again'. War broke out eleven months later.

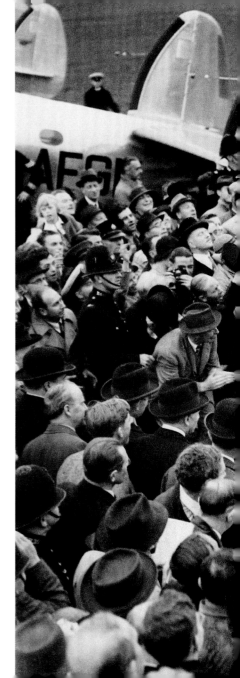

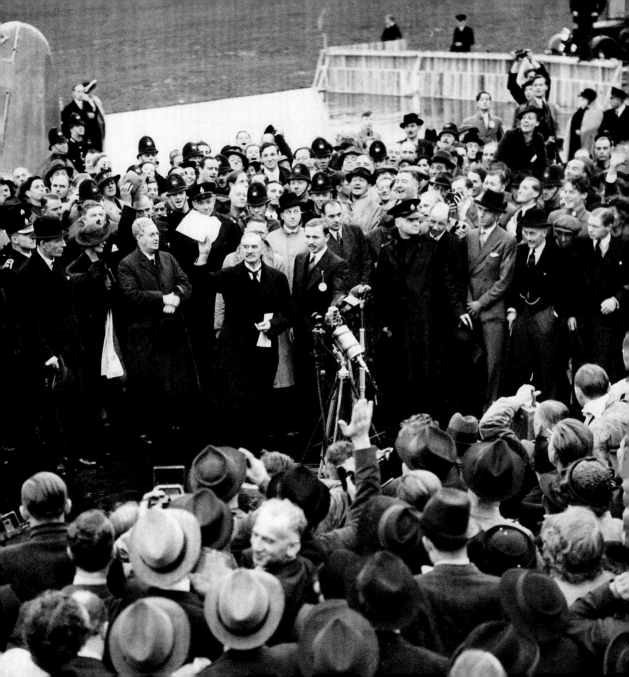

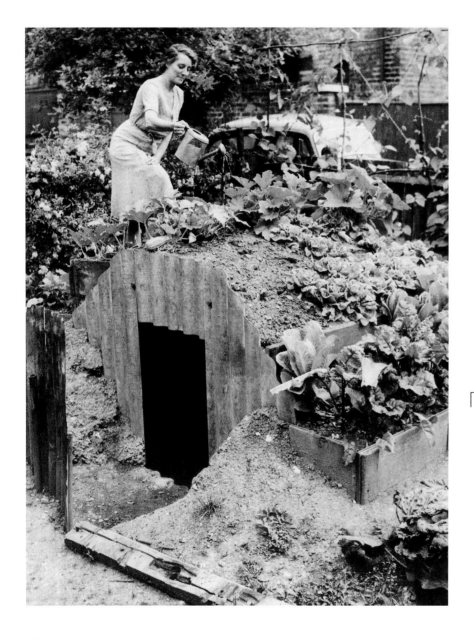

By the outbreak of war in September 1939, local councils had distributed more than a million corrugated steel Anderson air raid shelters. Properly dug in, these shelters provided good protection. In this July 1940 photograph, Alice Prendergast of Balham, London, tends a vegetable patch on the roof of her Anderson shelter.

With war looming, men and women were recruited to serve as air raid wardens. In this 1941 photograph, warden Florence Redmond wears a Women's Voluntary Service coat, with an Air Raid Precautions lapel badge. A widow, she also wears her late husband's medals, awarded for service in the First World War.

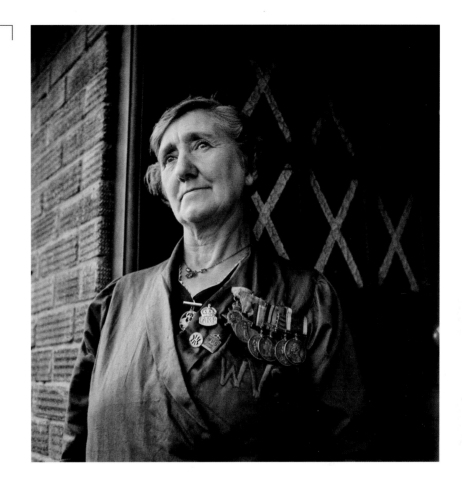

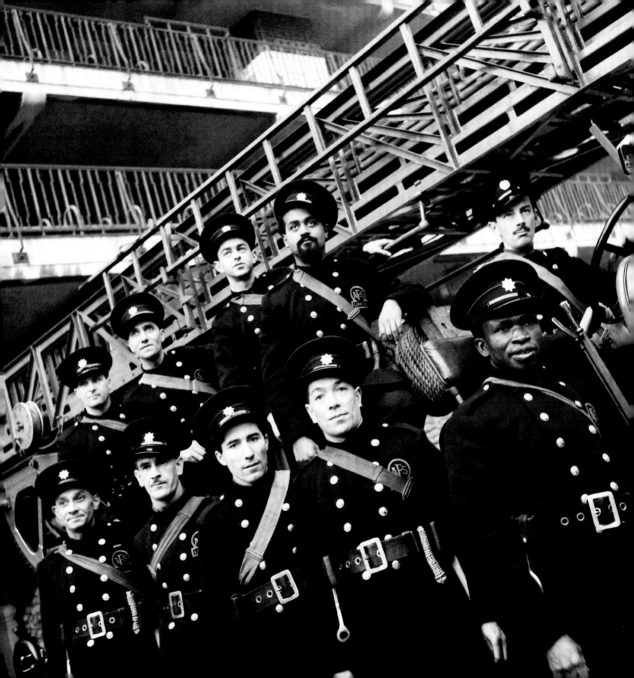

Anticipating the threat of widespread firebombing, a new Auxiliary Fire Service (AFS) was created to support existing fire brigades. In this 1941 photograph, men of a Hampstead AFS unit pose with their turntable ladder. They carry fire axes, a coiled rope and a hose spanner on their belts.

Knowing that bombing would result in countless injured people needing hospital treatment, councils expanded their local ambulance services. A group of female ambulance drivers knit and listen to the wireless while waiting for a call-out in March 1940. Their overalls, steel helmets and wellington boots hang ready behind them.

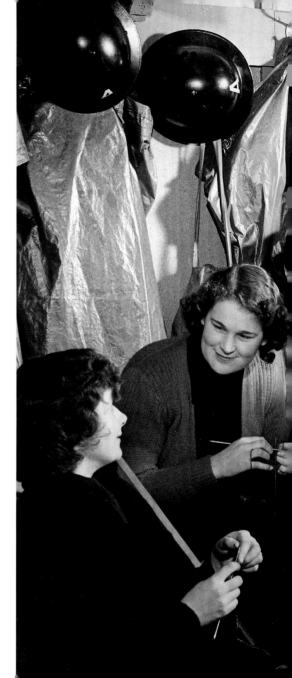

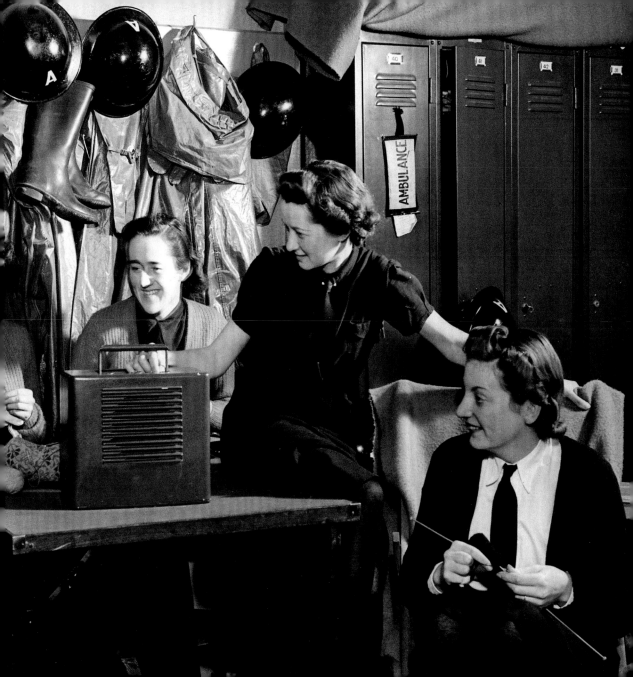

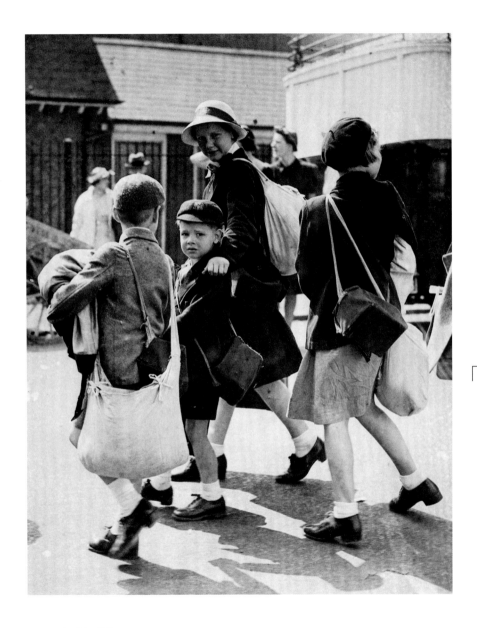

With the outbreak of war more than a million people, most of them children, were evacuated from cities threatened by bombing. For some, evacuation heralded a welcome new life in the countryside. For others, perhaps including this young boy leaving Chatham during a later evacuation in June 1940, the experience was distressing.

To prevent enemy bombers locating towns by their lights, a nightly blackout was imposed. With city street lights switched off and motorists required to shade their headlights, thousands of people were injured in night-time traffic accidents. At London's Piccadilly Circus in 1940, traffic passes the boarded-up statue of Eros.

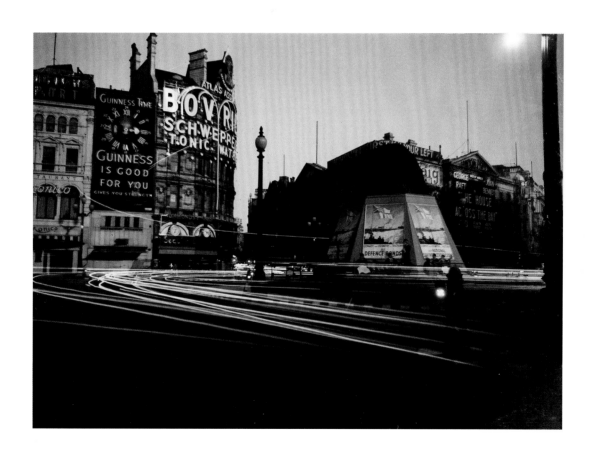

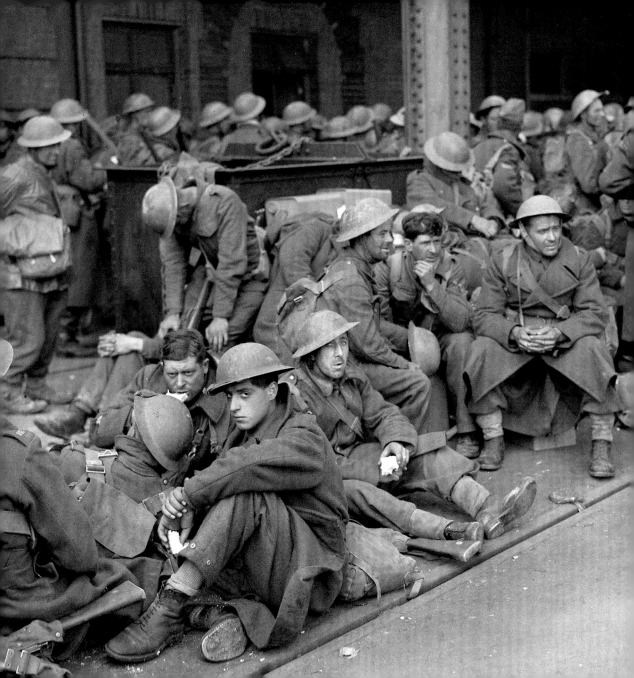

British troops, evacuated from France, rest at Dover on 31 May 1940. With France defeated and Britain forced to retreat across the English Channel, the German air force gained air bases from which to strike at British cities.

Besides bombing, Britain feared attacks with poison gas. As a precaution, tens of millions of gas masks were issued to the civilian population. In this image, taken in Sheffield in July 1940, air raid wardens help women with the fitting of their gas masks.

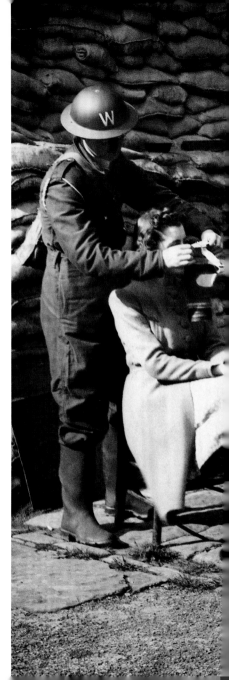

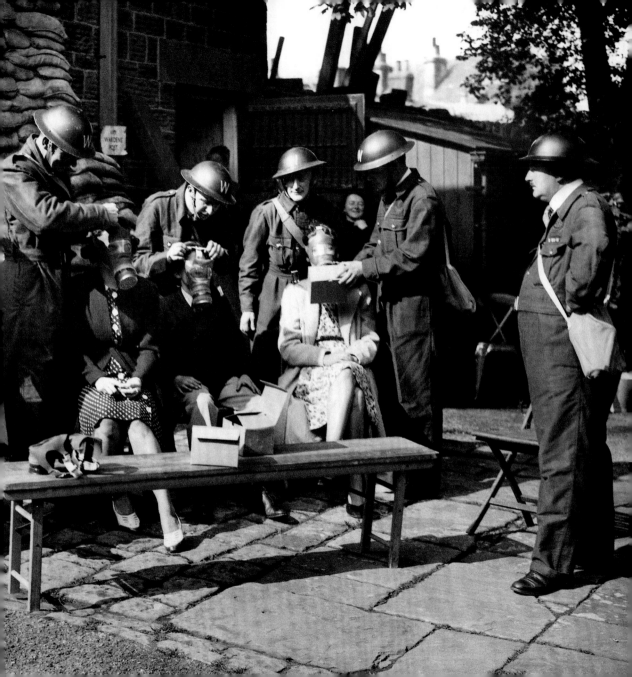

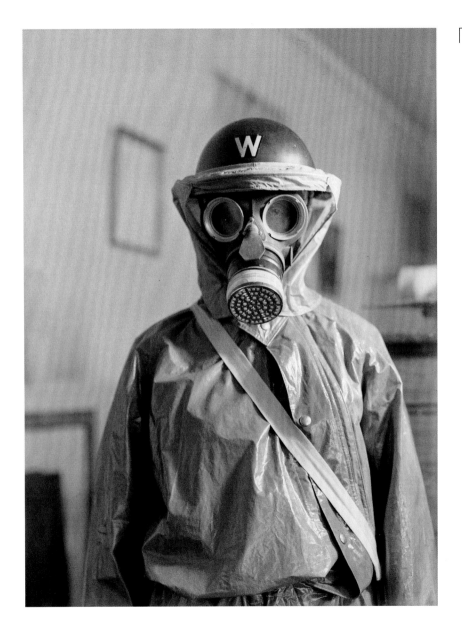

An air raid warden wears a full set of anti-gas clothing. His respirator protects him against poisonous gasses such as phosgene. Oilskin overalls protect against 'blister agents', including mustard gas or lewisite, which would cause blisters on exposed skin.

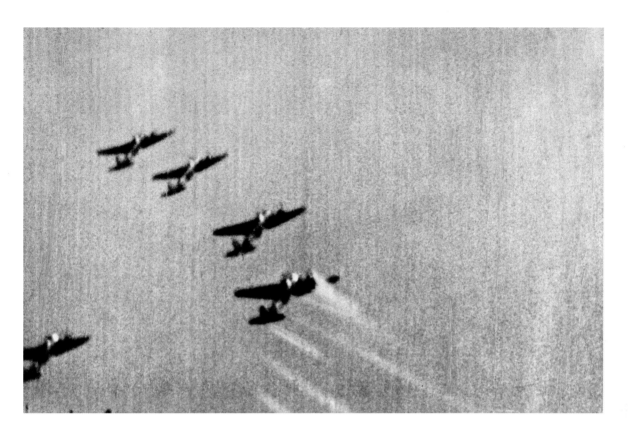

German bombers attack an aircraft factory at Southampton during the Battle of Britain on 26 September 1940. As Spitfire pilot John Bisdee opens fire, white streaks from tracer bullets can be seen. Bisdee flew with No. 609 Squadron, Royal Air Force, and this image was captured by a gun camera fitted to his Spitfire.

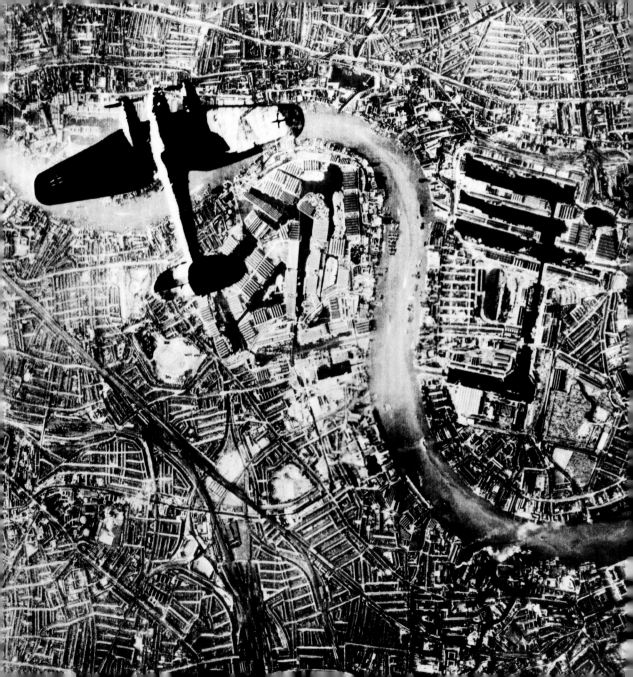

A German Heinkel 111 bomber in flight over east London on 7 September 1940, in the first raid of the Blitz. Believing that the preceding two months of intense aerial combat – the Battle of Britain – had neutralised the Royal Air Force, the German Luftwaffe shifted its focus to attack Britain's capital.

This German aerial photograph of the Isle of Dogs is annotated with potential targets. Near the centre — highlighted in a solid red box and numbered 19, 20 and 21 — are the grain silos, mills and powerplant of the McDougall's flour company. The Luftwaffe's first major raids against the city focused on the docks of east London.

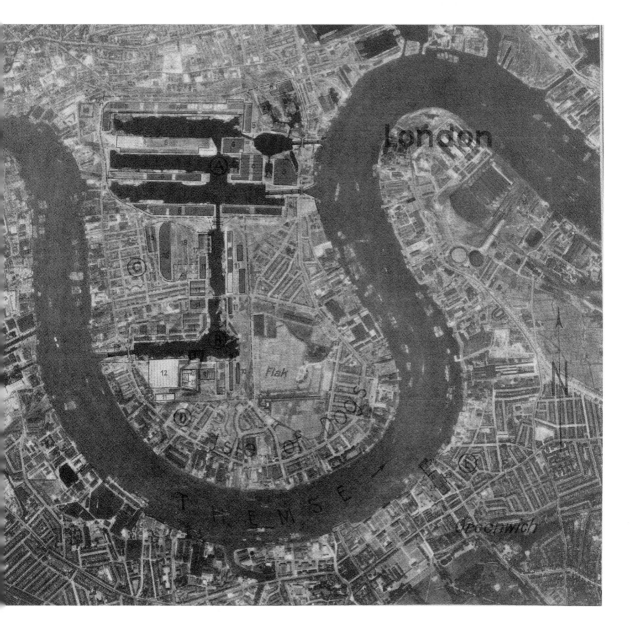

London

Greenwich

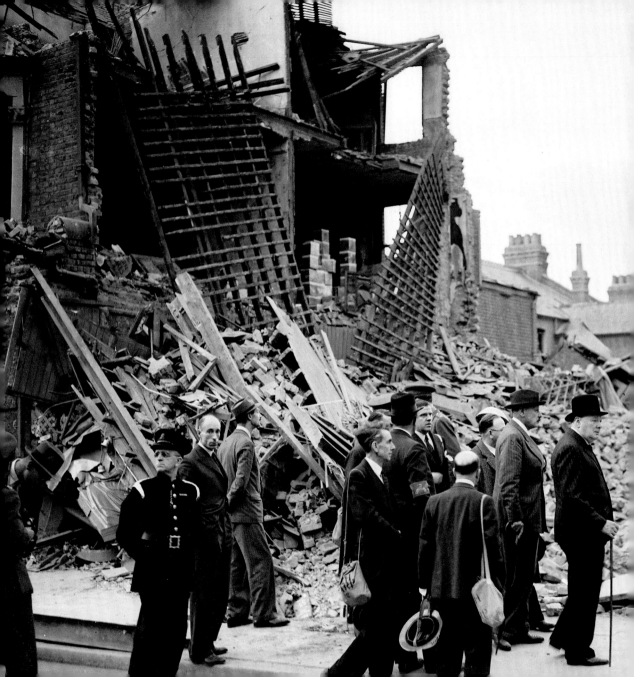

On 8 September 1940, the day after the Luftwaffe's first major raid on London, Prime Minister Winston Churchill visits the bomb-damaged East End. In a later speech, he would remark: 'What a triumph the life of these battered cities is, over the worst that fire and bomb can do!'

Bombing raids could cause catastrophic damage to infrastructure. In this 1940 photograph, engineers of the London Electric Supply Company work in a bomb crater to reconnect the power supply, as Auxiliary Fire Service firemen damp down smouldering rubble.

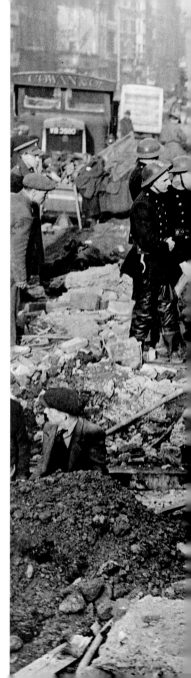

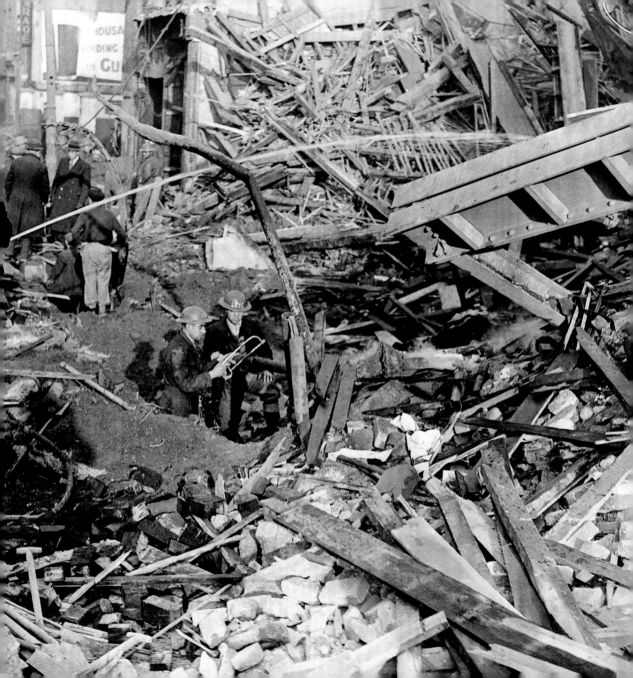

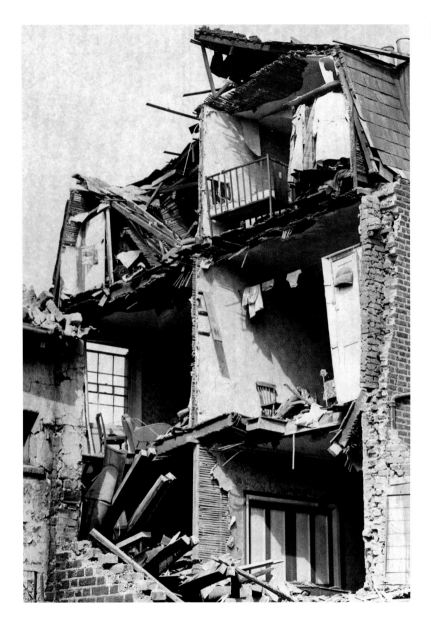

One psychological toll of the Blitz was that bombing violated the privacy of people's homes. In this 1940 photograph, a bomb has torn open a London house, revealing a bedroom, clothes in a wardrobe, a sitting room and laundry hanging on a washing line.

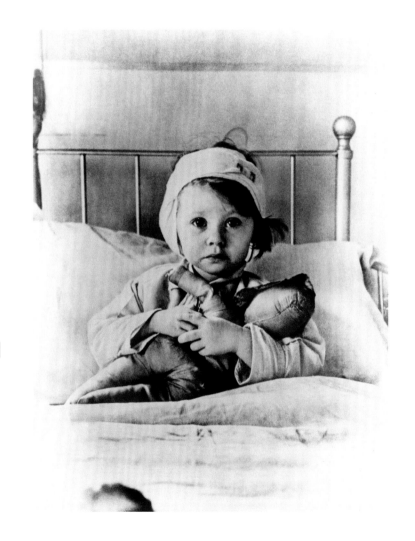

Three-year-old Eileen Dunne sits up in bed at London's Great Ormond Street Hospital after being injured in a raid in September 1940. This photograph, by celebrated society photographer Cecil Beaton, appeared on the cover of the American magazine *Life*. At a time when the United States remained neutral, images like this helped garner sympathy for Britain's war effort.

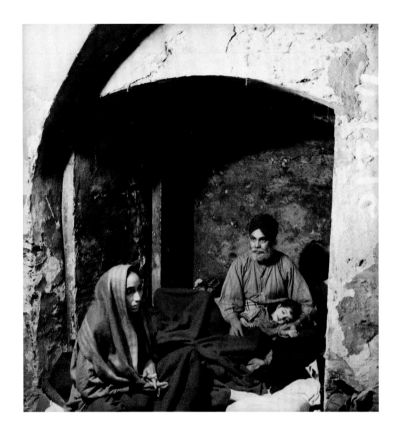

In late 1940, photojournalist Bill Brandt toured London's air raid shelters for the Ministry of Information. He photographed this Sikh family sheltering in the crypt of Christ Church, Spitalfields. German-born Brandt was a leading documentary photographer; his work frequently appeared in magazines including *Picture Post*.

With the outbreak of the Blitz, thousands sought shelter in London's Underground railway stations. In this photograph, taken by Bill Brandt during his tour of London's air raid shelters, the platform at Elephant & Castle station is crowded with sleeping bodies.

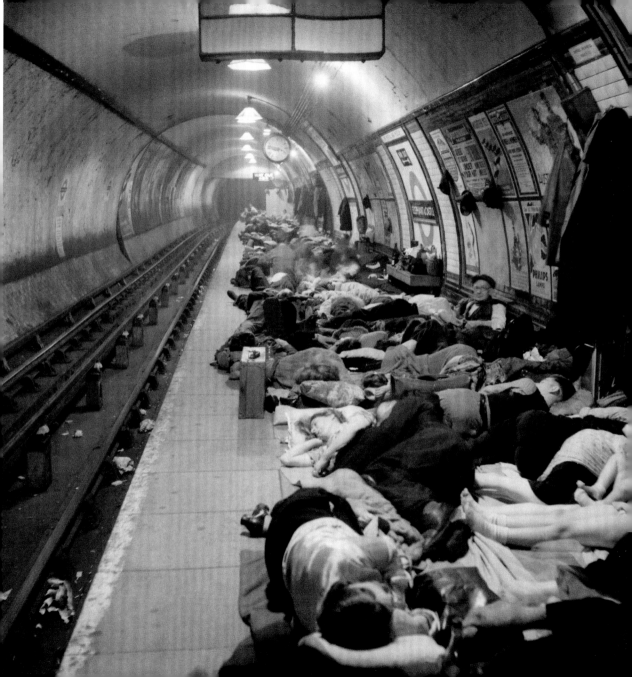

The tunnels of the London Underground seemed to offer a safe place to shelter. On the night of 14 October 1940, a bomb struck Balham tube station. Catching a passing bus in its crater, the blast collapsed the platform tunnels. In a flood of earth, water and sewage, more than 60 people were killed.

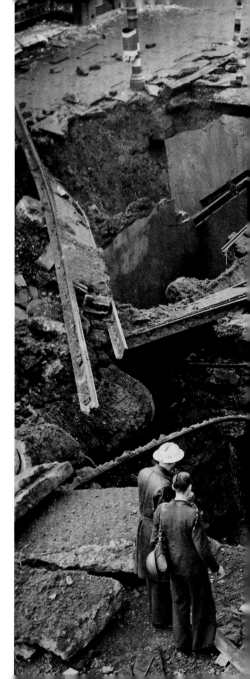

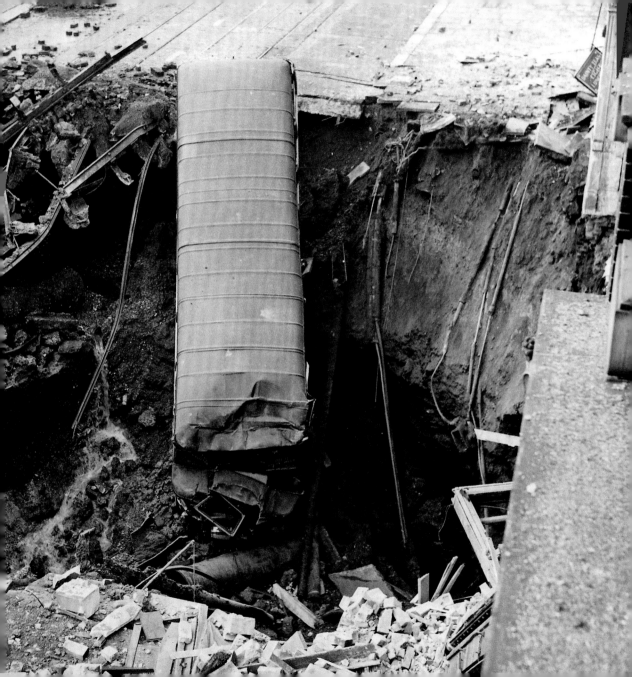

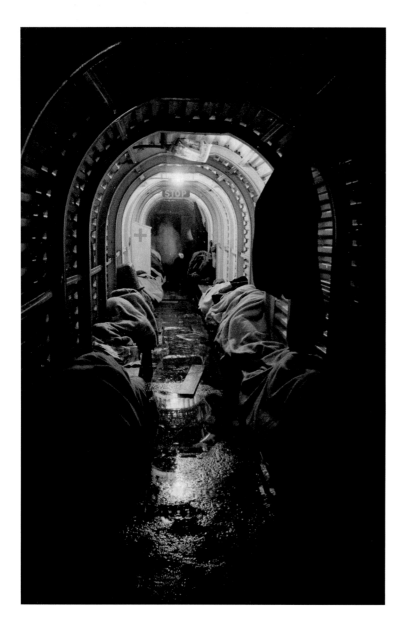

When Britain prepared for war, air raids were expected to be brief and occur in daylight. Few shelters were designed to provide sleeping accommodation, and many were extremely uncomfortable. In a trench shelter waterlogged by rain, photographed in 1940, people sleep on hard, narrow benches.

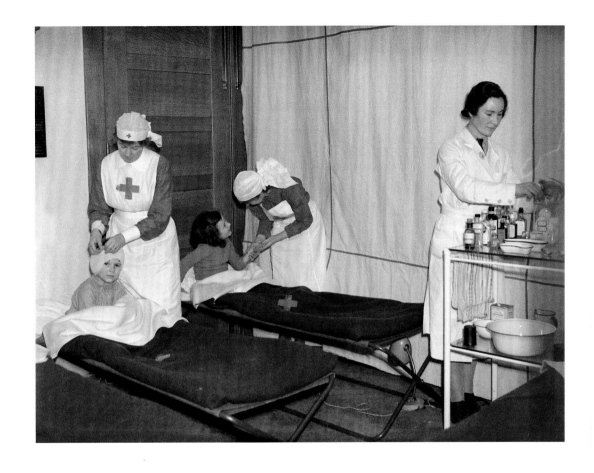

In this photograph taken in 1940 at a shelter and rest centre at John Keble Church in Mill Hill, north London, nurses look after two injured children, while a doctor inspects medical supplies.

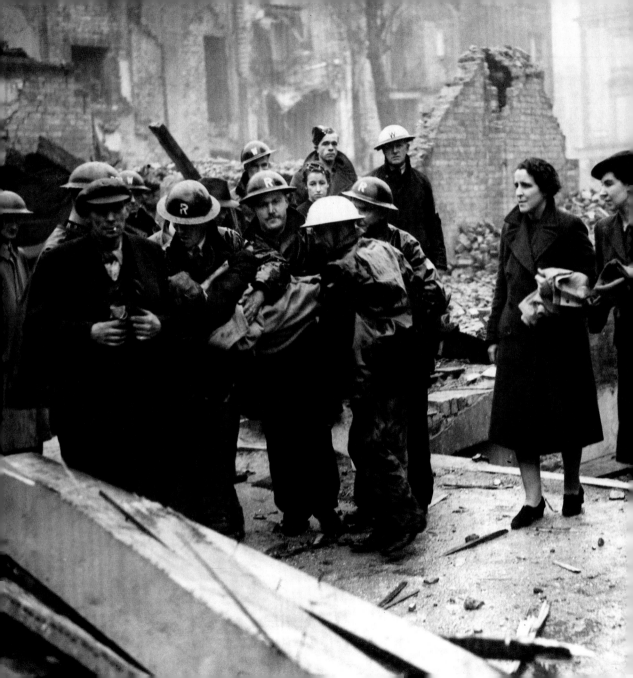

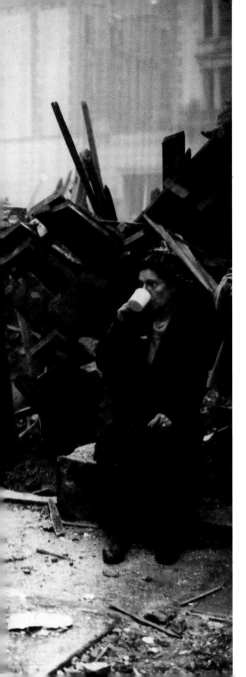

At a bomb site in Westminster on 4 November 1940 a rescue party – with an 'R' on their helmets – carry away a casualty. Two women, possibly members of the Women's Voluntary Service, stand ready with clean blankets.

On the night of 29–30 December 1940, the Luftwaffe struck the City of London in one of the most destructive fire raids of the Blitz. *Daily Mail* photographer Herbert Mason was on the roof of the newspaper's offices near Fleet Street. Catching sight of St Paul's Cathedral dome, illuminated by flames and wreathed in smoke, Mason captured this iconic image.

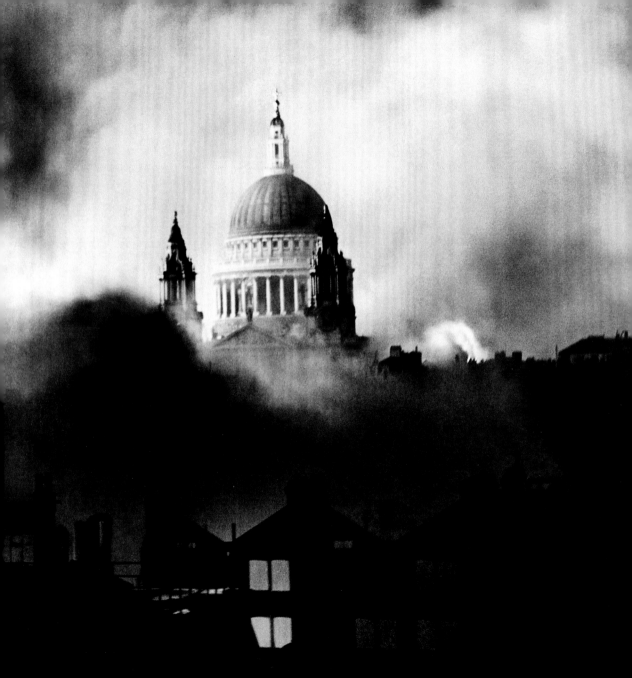

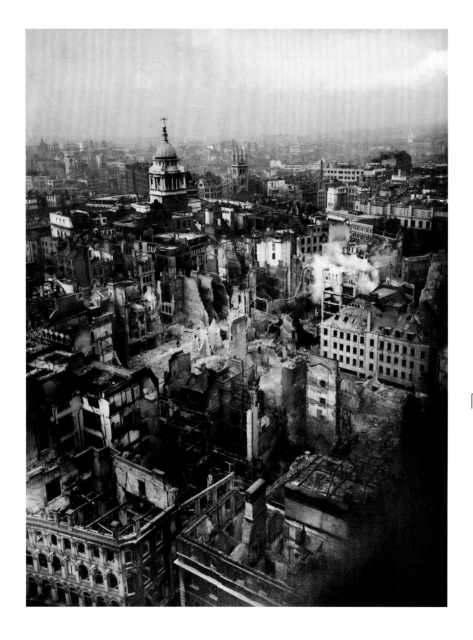

The view from the Golden Gallery, above the dome of St Paul's Cathedral, after the catastrophic fire raid of 29–30 December 1940. In the foreground, the shattered buildings of Paternoster Row, the centre of London's publishing industry. In the distance, the figure of Justice stands on the dome of the Old Bailey.

During the war the Imperial War Museum closed to the public and removed much of its collection to safety outside of London. On 31 January 1941, the museum's naval gallery suffered a direct hit. This Short 184 seaplane had flown at the Battle of Jutland in 1916. Its fabric-covered wings and fuselage were shredded by the explosion.

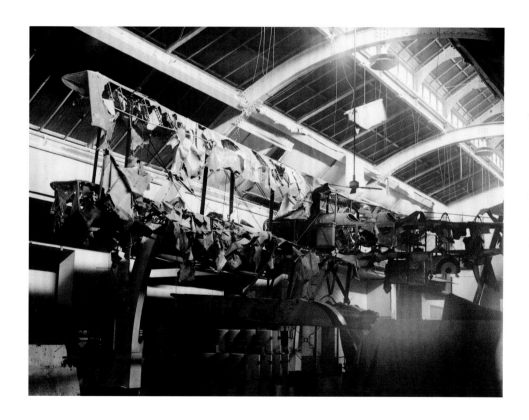

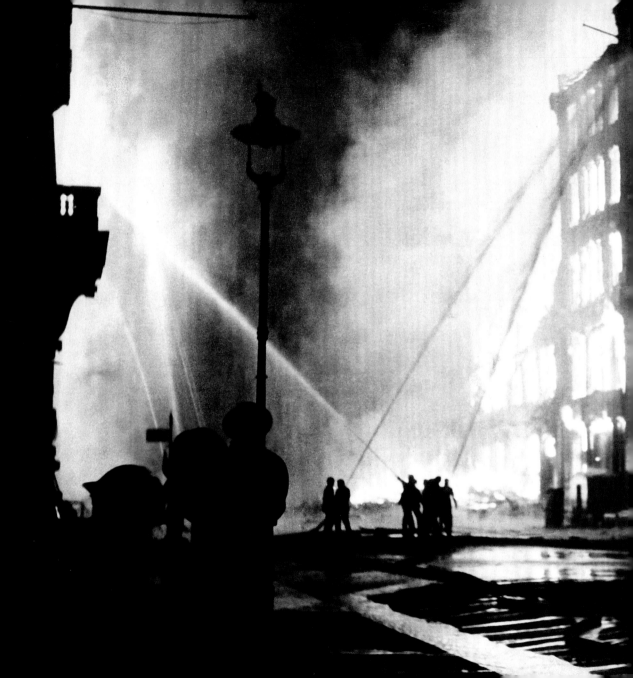

Firemen battle flames on London's Queen Victoria Street on 10–11 May 1941, the last major raid of the Blitz. This heavy raid killed more than 1,400 people, and damaged historic buildings including the House of Commons Chamber and Westminster Abbey.

A building's facade collapses in Queen Victoria Street, London. This building was the headquarters of the Christian charity The Salvation Army and was gutted by fire following the destructive raid on 10–11 May 1941.

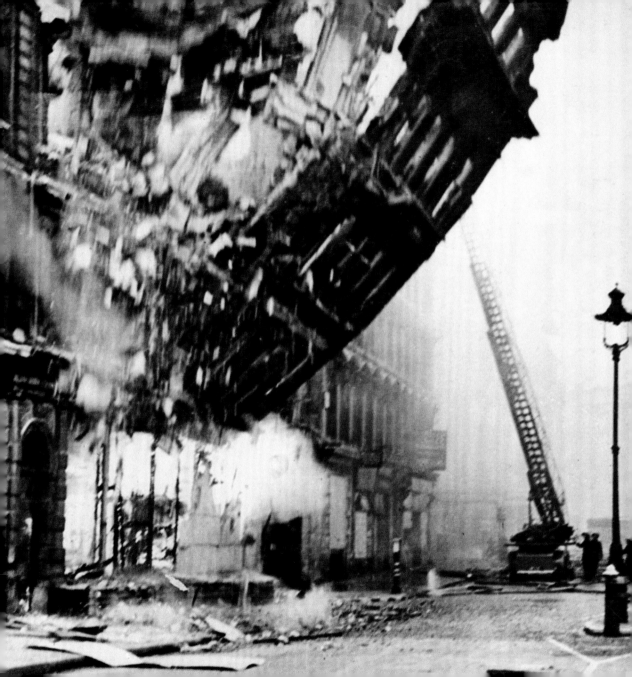

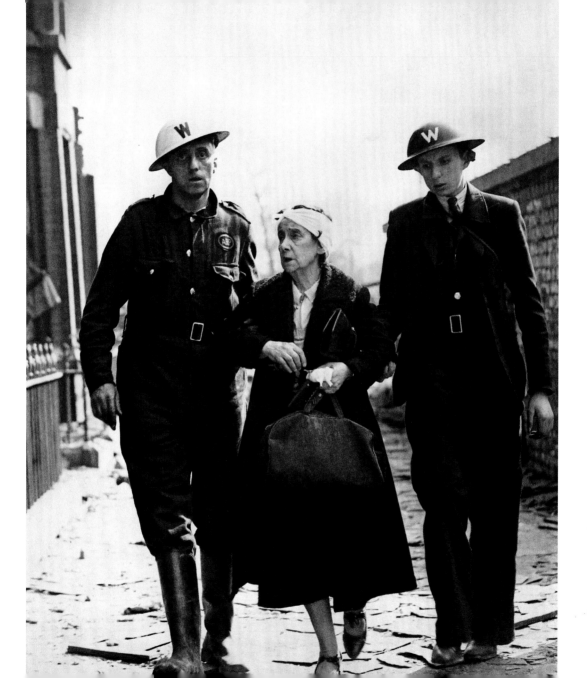

The Blitz began in London, but the Luftwaffe's bombers soon attacked targets across the United Kingdom. After being bombed out of her home in Liverpool in May 1941, an elderly lady is helped by two air raid wardens from a First Aid Post to a rest centre.

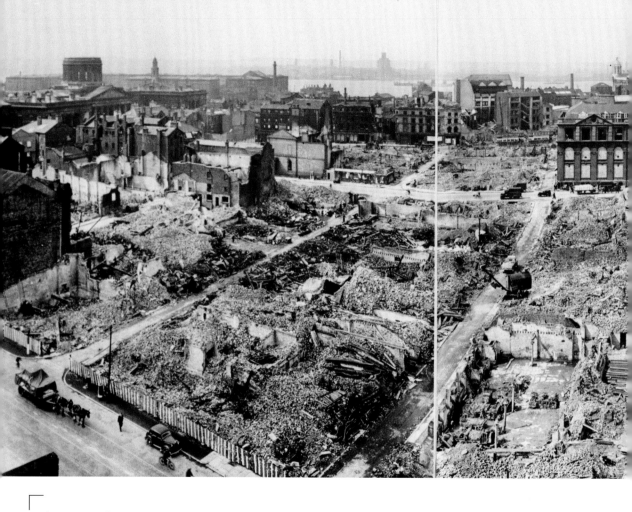

A panorama of bomb damage in Liverpool, taken in 1942. A key port, Liverpool was the most heavily bombed British city after London, struck by almost 3,000 tonnes of high explosive bombs and 300 tonnes of incendiaries. The two towers of the city's famous Royal Liver Building can be seen on the skyline.

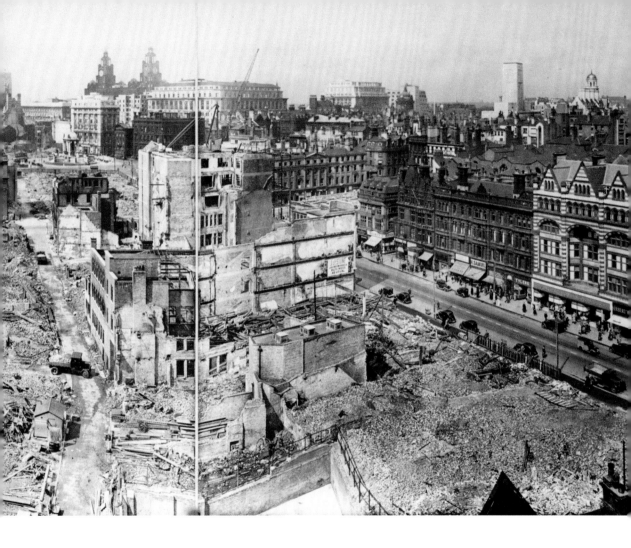

The city of Coventry was a key industrial and engineering centre. In November 1940 a devastating raid killed 568 people and injured 1,256. In this image, a shattered bus stands in the city centre as firemen damp down a smouldering building.

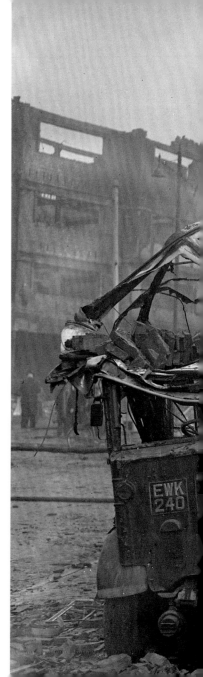

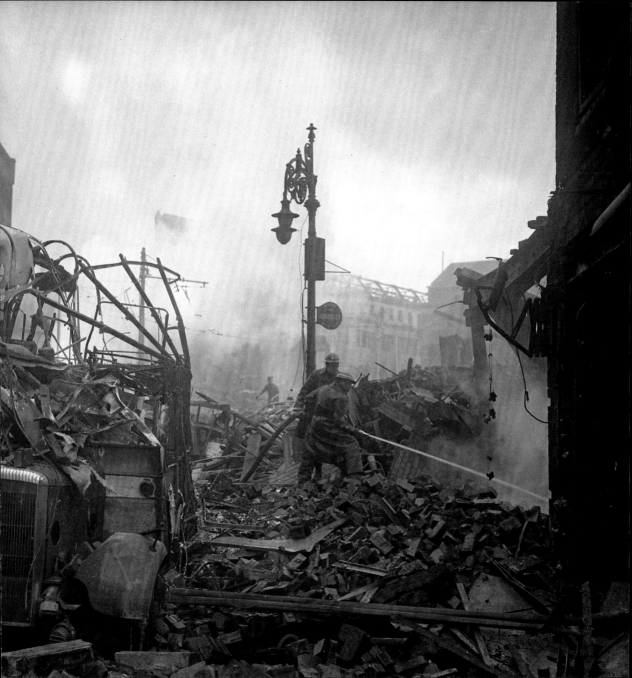

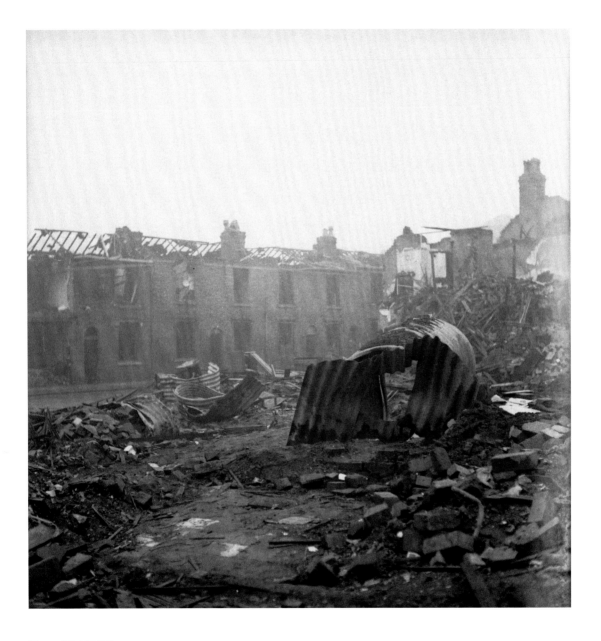

Birmingham was a major
industrial city. Heavy raids
in November 1940 killed at least
682 people and injured more
than a thousand. On James
Street in Aston Newtown, on
a site already partially cleared,
the warped shell of an Anderson
shelter remains standing.

As a major port and industrial city, Bristol was heavily bombed. On 24 November 1940, bombs destroyed the ancient church of St Mary le Port (left). The towers of All Saints (centre) and Christ Church with St Ewen (right) can also be seen.

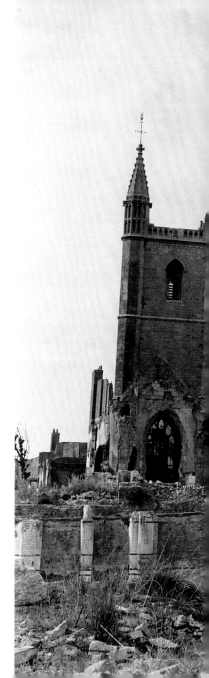

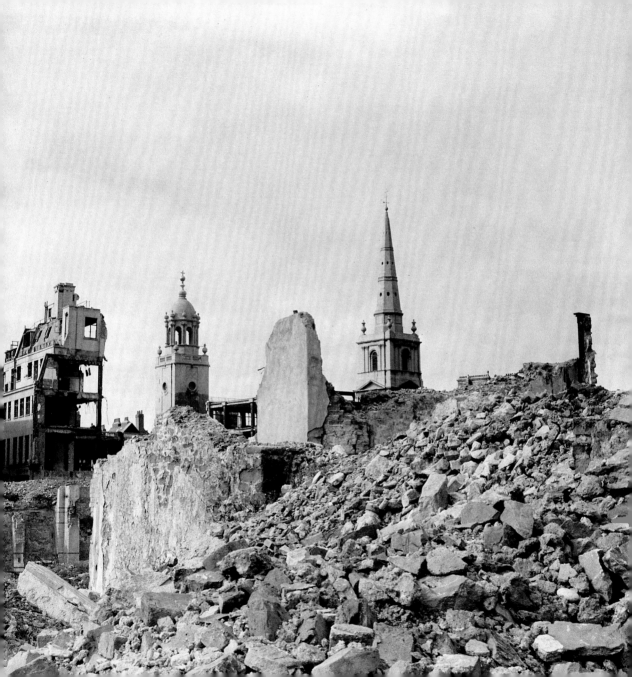

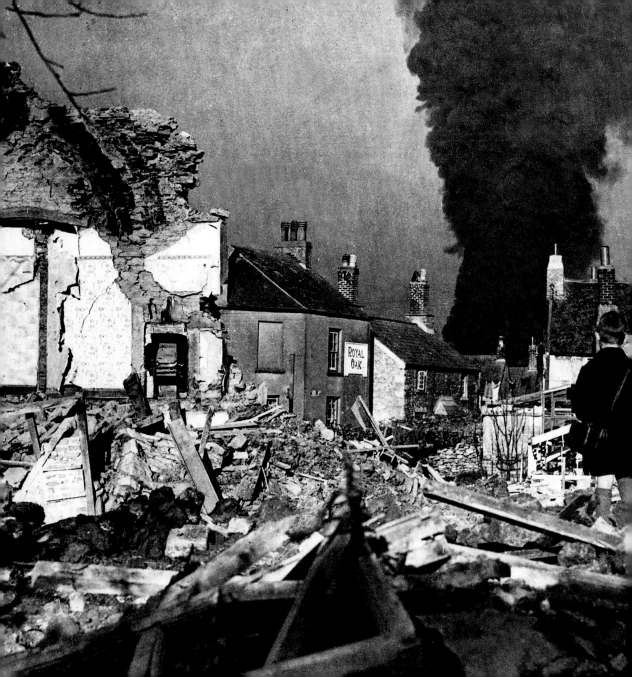

Standing amid rubble, two boys watch a column of black oil smoke rise from a naval fuel depot at Turnchapel, near Plymouth, following a raid on 27 November 1940. As a south-coast port housing the vital Devonport naval base, Plymouth was raided repeatedly.

Sheffield, a city famous for steelmaking, was heavily bombed in two raids during December 1940. Some 750 people were killed, and 3,000 homes and shops destroyed. Here pedestrians pass wrecked trams in Fitzalan Square, and the ruins of a C&A clothes shop.

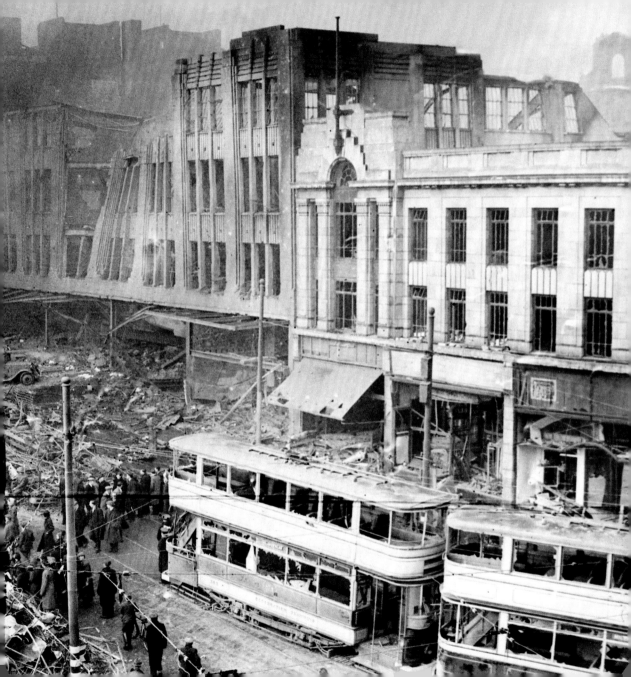

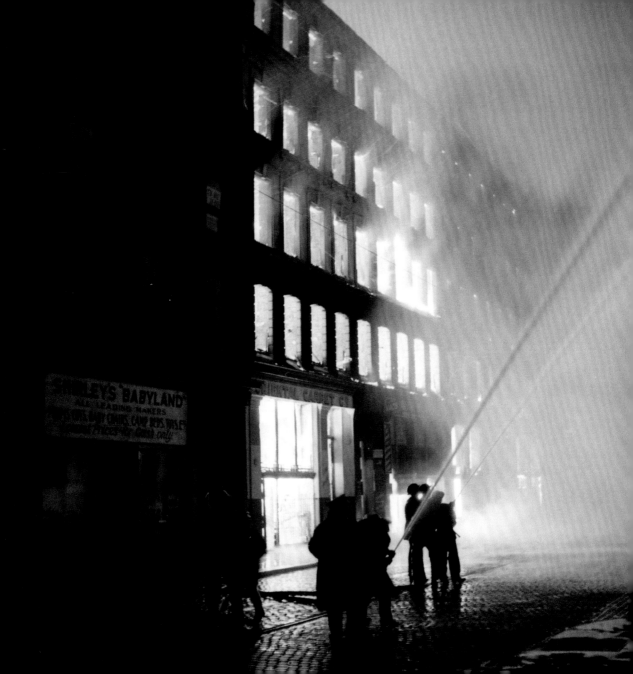

Manchester was heavily bombed shortly before Christmas 1940. In two nights of raids almost 700 people were killed, and more than 8,000 homes destroyed or rendered uninhabitable. Here firemen fight fires in the centre of the city.

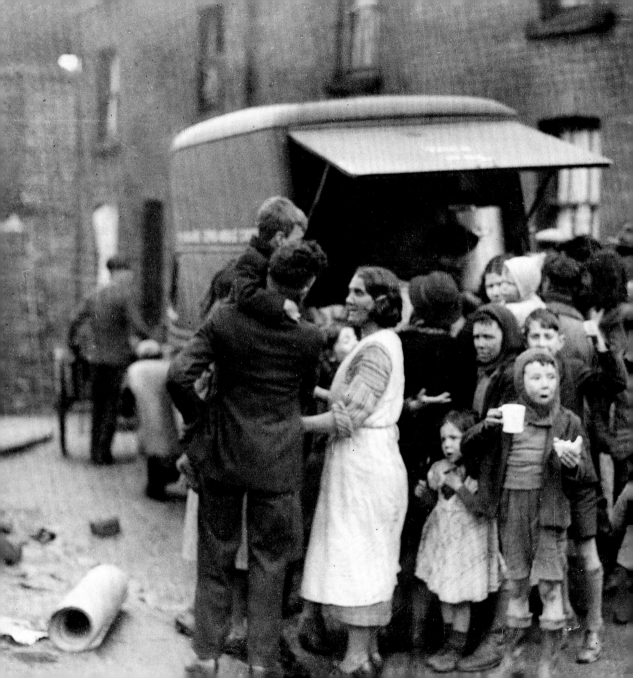

In February 1941, the Welsh port city of Swansea was struck by three nights of raiding. A mobile canteen van dispenses hot tea and sandwiches to bombed-out families. Mobile canteens like this were a valuable resource, helping to maintain the morale of the local population and exhausted rescue workers.

In March 1941, Glasgow and neighbouring Clydebank in Scotland were bombed. Despite being far from the Luftwaffe's air bases, Glasgow was hit by more than 900 tonnes of bombs and incendiaries. In Clydebank 35,000 people were rendered homeless. Glaswegian civilians pass bombed tenement houses. A woman pushes a pram laden with suitcases.

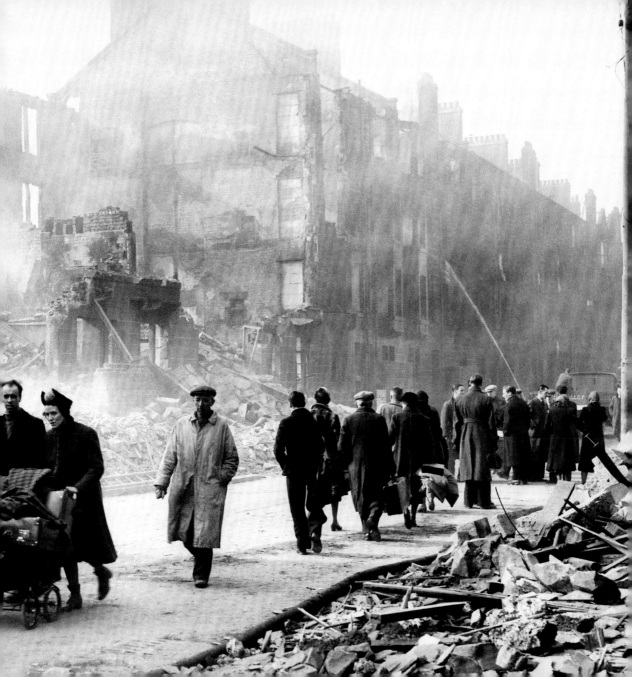

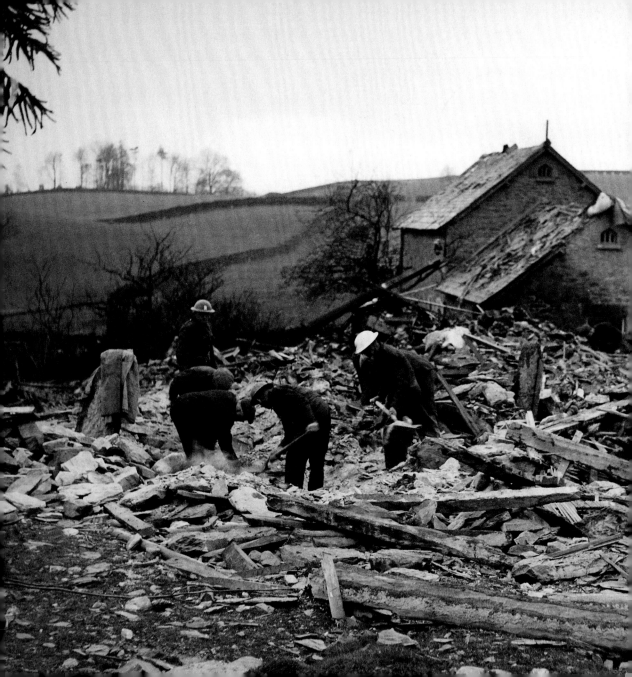

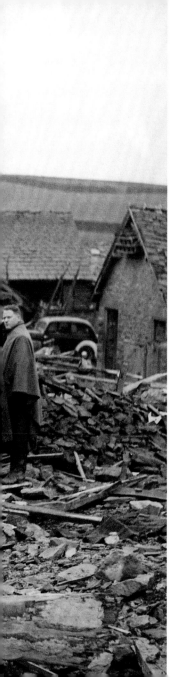

Most bombs fell on major towns and cities, but villages and isolated rural farms could also be hit. In April 1941 a large bomb, likely jettisoned from an aircraft attacking the industrial port at Barrow-in-Furness in Lancashire, fell on Cooper House at Selside, near Kendal in the Lake District. Eleven people, including five London evacuees, were killed.

Grain pours from a bombed silo in Hull, May 1941. As a port on Britain's north-east coast, Hull was easily located by German bombers. For its size, Hull was one of Britain's most heavily bombed towns, suffering 1,200 dead and 3,000 seriously injured throughout the war. A staggering 152,000 people – almost half the city's total population – were made temporarily homeless.

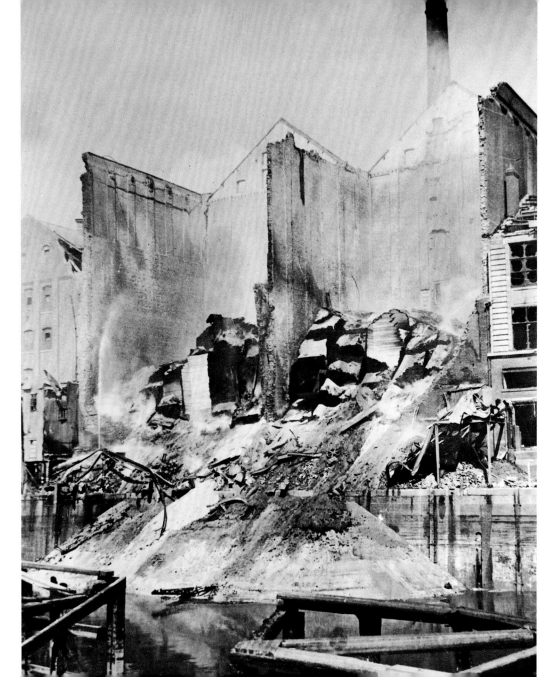

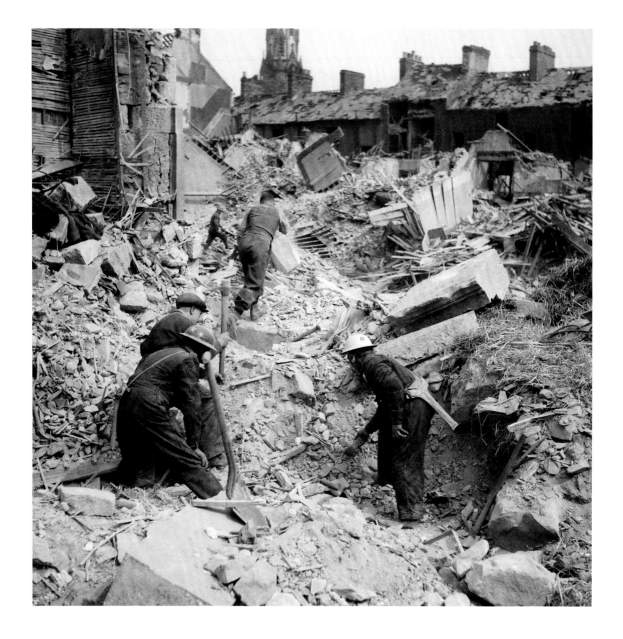

Belfast, the industrial and ship-building capital of Northern Ireland, was bombed in spring 1941. A rescue party looks for survivors among rubble in Eglinton Street on 7 May 1941, following the last raid on the city. In total more than a thousand people were killed in Belfast.

Defending cities against night bombing was difficult. Short of guns and gun-laying radars, anti-aircraft gunners initially struggled to hit enemy aircraft cloaked in darkness. Here gunners fire a 40mm Bofors gun at dusk during training at Manorbier in south Wales on 19 April 1941.

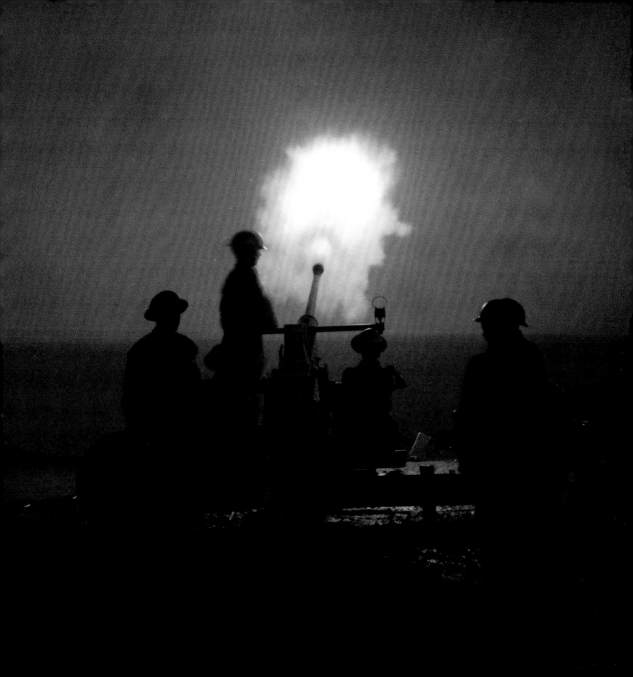

Royal Air Force pilots hunted enemy bombers in the night skies. This two-seat Boulton Paul Defiant, photographed in 1941, was crewed by pilot Desmond Hughes and gunner Fred Gash. They shot down five enemy aircraft, as denoted by the five swastika victory marks. Three of their victories were during the Blitz.

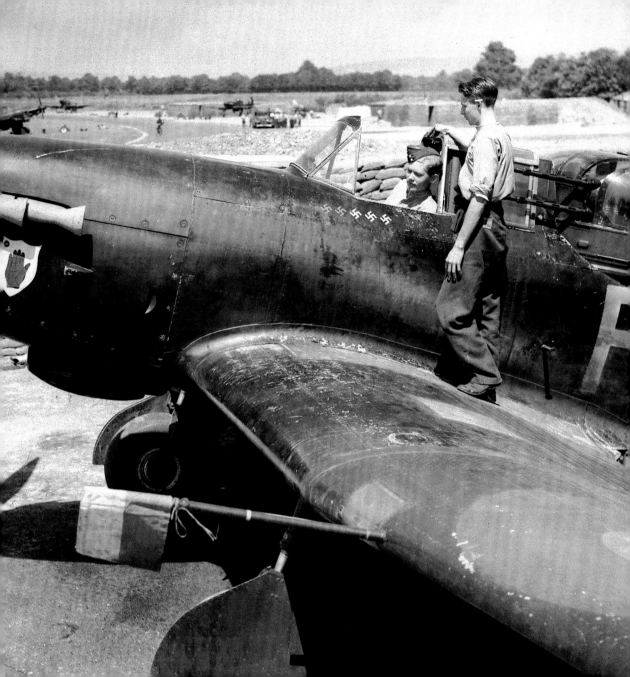

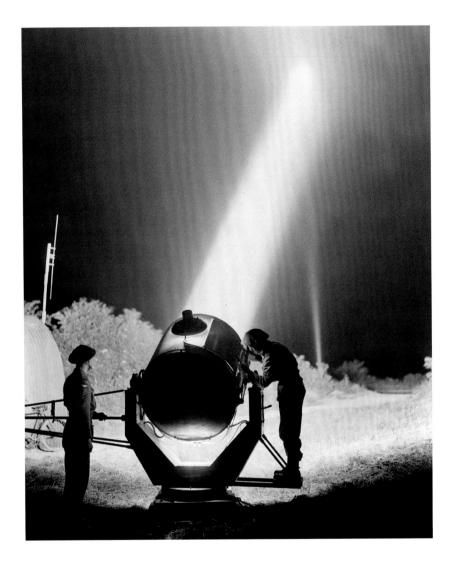

Searchlights were a key element of Britain's defences. By illuminating enemy aircraft, they made the bombers easier targets for anti-aircraft guns, and searchlight beams dazzled and discouraged enemy bomber pilots. But shortages of radar sets and anti-aircraft guns hampered their effectiveness.

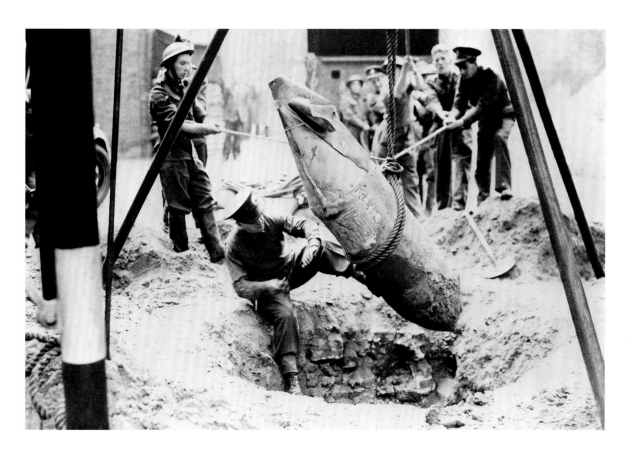

Whenever bombs were dropped, some would fail to explode. Unexploded bombs were hazardous and disruptive. Disposing of these so-called 'UXBs' required specialist training and cool courage. Lieutenant Robert Davies GC works on a 500-kilo parachute mine in the grounds of the German Hospital in Dalston, London, November 1941.

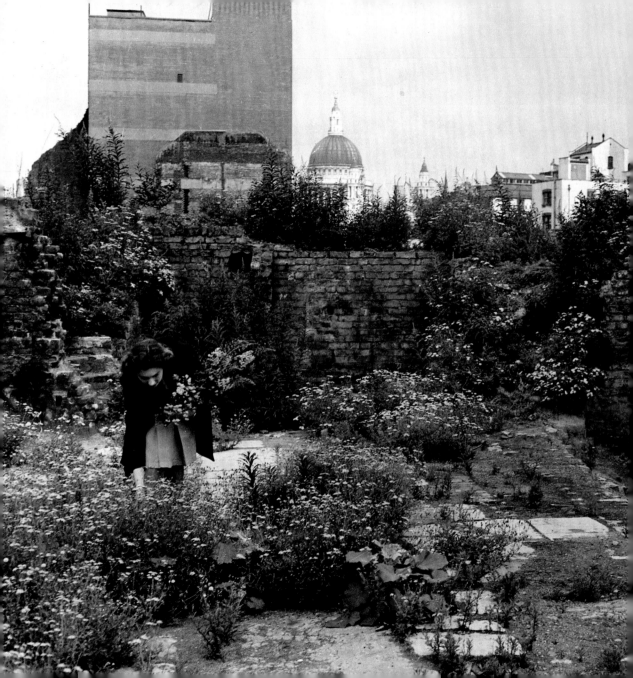

A woman picks flowers on a bombsite near St Paul's Cathedral. Bombed buildings were fertile ground for wildflowers, and rosebay willowherb became so widespread that people called it 'bombweed'. Wildflowers attracted insects and unusual bird species, such as black redstarts and wheatears, which would nest among broken buildings.

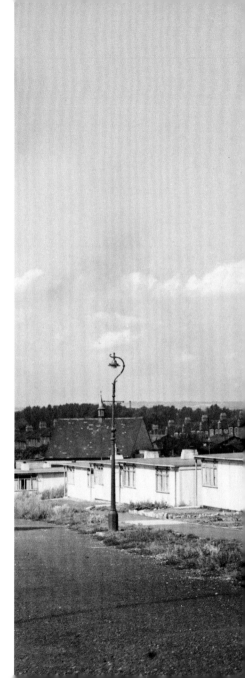

The Blitz caused a severe housing shortage. One temporary solution was the mass production of prefabricated or 'prefab' houses, such as this estate in Hull photographed in December 1955. While only intended to stand for ten years until conventional housing stock was rebuilt, some prefabs remain in occupation to this day.

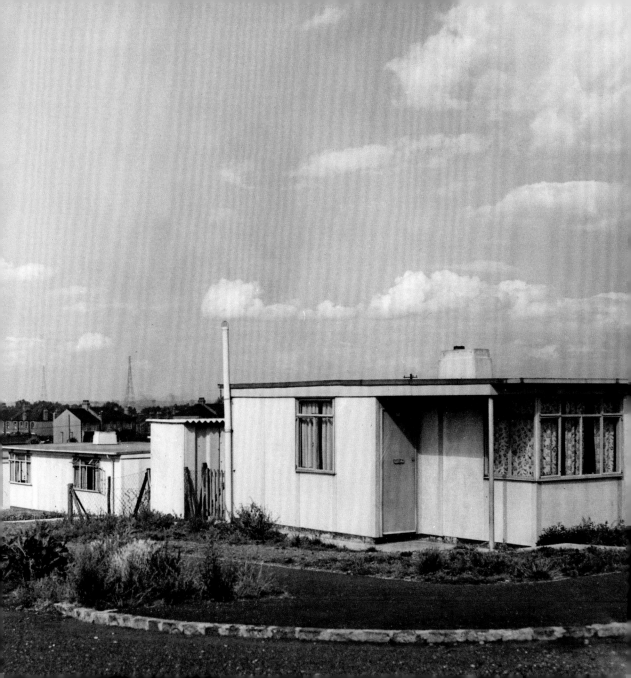

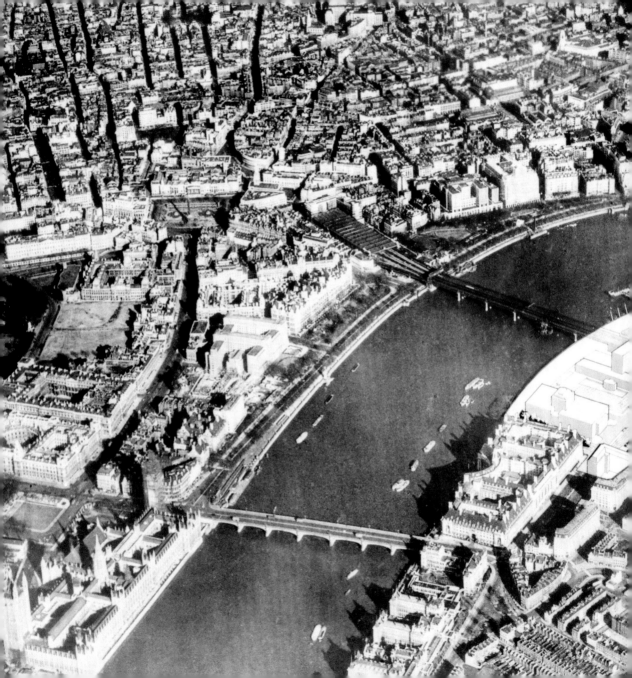

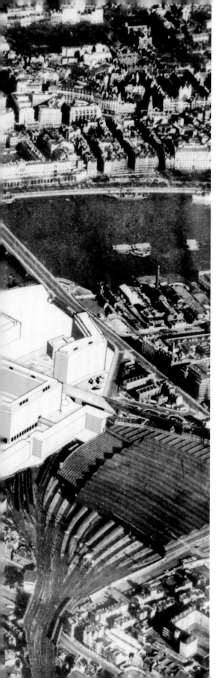

The Blitz posed a question: how should Britain rebuild its battered cities? Ambitious plans were developed, many of which would define urban areas for decades. This 1956 image includes drawings of the Shell Centre, constructed from 1957, and the 1951 Royal Festival Hall, near London's Waterloo station.

Coventry's ruined cathedral, seen here in spring 1944, has become a key site for commemorating the Blitz. In 1959 Coventry was twinned with the German city of Dresden, destroyed by Allied bombing in 1945. In the 1960s a new Coventry cathedral was built, and its clergy have worked to promote peace and reconciliation.

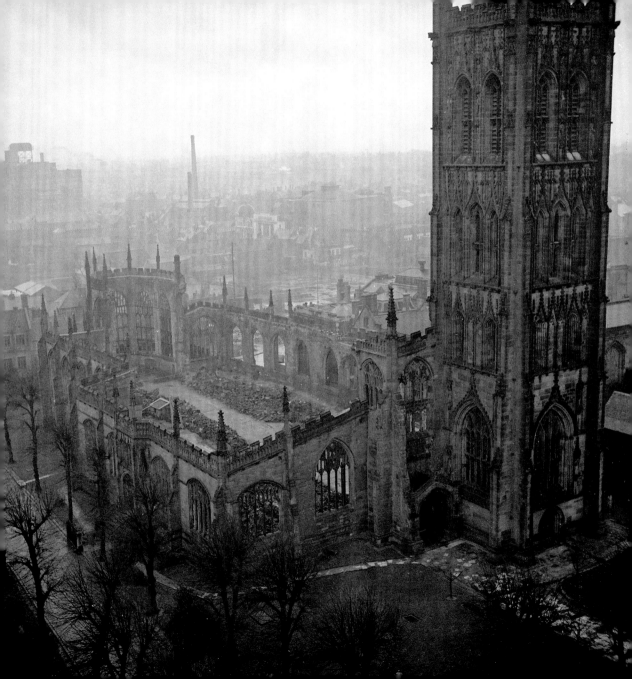

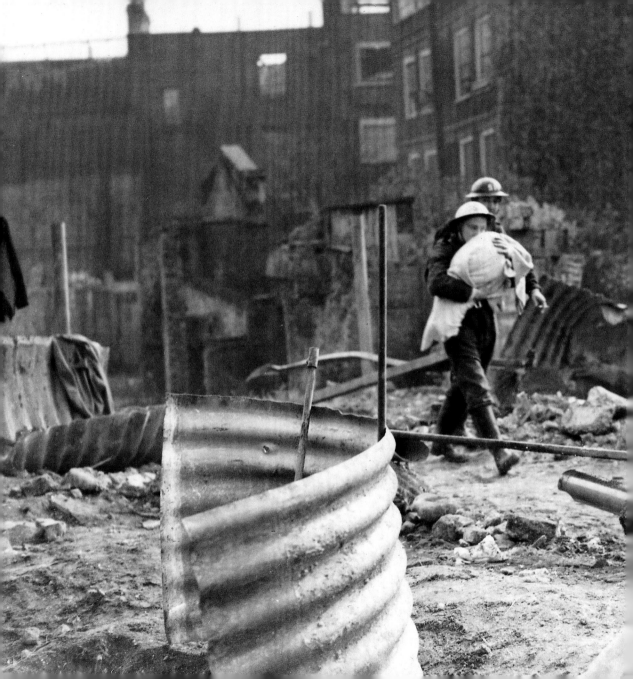

The Blitz was a pivotal period of modern British history. Its memory — of solidarity, common effort, sacrifice and courage — has been frequently invoked by politicians and journalists.

More than 30,000 tonnes of bombs and incendiaries were dropped on Britain between 1940 and 1941, killing more than 40,000 people. But a single bomb could cause incomprehensible personal tragedy. In London in October 1940, a member of a stretcher party carries a bundle containing a dead baby.

Image List

HU 36220A (detail), D 2239, HU 63827A, D 4862, D 5544, HU 104542, HU 59252, D 712, H 1647, HU 103753, D 3494, CH 1827, C 5422, LBY LUFT 1546 (detail), H 3978, D 1475, HU 72363, MH 26395, D 1516, D 1568, HU 131459, D 1553, D 1438, HU 131643, HU 36220A © Associated Newspapers Limited, HU 64317, MH 116, HU 1129, HU 650, HU 36162, D 5984, H 5593, D 4127, D 16643, HU 140002, HU 36207, H 6325, HU 36143, HU 36232, ZZZ 8228C, HU 660, H 9476, H 8990, CH 4810, CH 10630, HU 3053, HU 110876, (MOW) T 61478, (MOW) T 64698, D 18093, HU 131368.

About the Author

Ian Kikuchi is a Senior Curator (Historian) at Imperial War Museums, based at IWM London. Starting at IWM as a shop assistant at HMS Belfast in 2006, he joined the museum's film archive as an assistant curator in 2007. Since 2011, he's curated exhibitions including the First World War Galleries and War Games at IWM London, and Churchill and the Middle East at Churchill War Rooms.

Acknowledgements

I would like to dedicate this book to the memory of my grandparents, Molly and Brian Hardcastle, who lived through the Hull Blitz as teenagers. I'd like to thank Lara Bateman for her skilful work in the production of this book. Thanks are also due to curatorial colleagues including Helen Mavin, Hilary Roberts, Alan Wakefield and Tony Richards for their comments and assistance. Special thanks go to my dear wife Abigail, whose tireless support underpins everything I do.

The quotation by Winston Churchill on page 31 is kindly reproduced with permission of Curtis Brown, London on behalf of The Estate of Winston S. Churchill © The Estate of Winston S. Churchill.